Flying
UNDeRWatER

Apr. 16/13

poems new and selected by **Eva Tihanyi**

For Mary-Ann,

Thank you for coming out tonight. Thanks!

Cheers,

Eva

inanna poetry & fiction series

INANNA Publications and Education Inc.
Toronto, Canada

The publisher gratefully acknowledges the support of the Canada Council for the Arts and the Ontario Arts Council for its publishing program.

The publisher is also grateful for the kind support received from an Anonymous Fund at The Calgary Foundation.

Cover design: Val Fullard
Interior design: Luciana Ricciutelli

Library and Archives Canada Cataloguing in Publication

Tihanyi, Eva, 1956-
 Flying underwater : poems new and selected / Eva Tihanyi.

(Inanna poetry and fiction series)
Issued also in an electronic format.
ISBN 978-1-926708-73-7

 I. Title. II. Series: Inanna poetry and fiction series

PS8589.I53F59 2012 C811'.54 C2012-904758-9

Printed and bound in Canada.

Inanna Publications and Education Inc.
210 Founders College, York University
4700 Keele Street, Toronto, Ontario M3J 1P3 Canada
Telephone: 416.736.5356 Fax: 416.736.5765
Email: inanna.publications@inanna.ca
Website: www.inanna.ca

For Constance
Yesterday, tomorrow, and most of all now.

Contents

from *Saved by the Telling* (1995)

from *Restoring the Wickedness* (2000)

from *Wresting the Grace of the World* (2005)

from *In the Key of Red* (2010)

New Poems

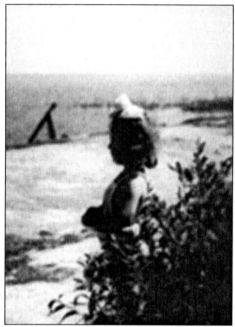

Eva Tihanyi, c.1960

Fish do not worry
 where the shore begins.

 —Rumi

Foreword

The selected poems of Eva Tihanyi tell their imaginative story, following a narrative arc through feeling and event. Along the way they question and wonder, scrutinizing art, weaving through relationship, pondering personal heritage. Throughout her journey — whether luminous, humorous or critical — Tihanyi's talking partner is desire, creating a dialogue of love, loss and revelation through which poetry is made.

The early lyrics of *A Sequence of the Blood* (1983) flow with romantic yearning while natural imagery expresses the interior life, often enlivened with ironic self-recognition. *Prophecies Near the Speed of Light* (1984) expands the personal to include the elemental — sun and moon — and an almost mythic acknowledgement of suffering ("Breaths Along the Run") that brings renewal.

Published between 1995 and 2005, Tihanyi's middle three books — *Saved by the Telling, Restoring the Wickedness* and *Wresting the Grace of the World* — represent a culmination of poetic energy that casts various light on some of her most enduring subjects: art, feminism, the grandmother who inspires her. They contain warning that "a woman's place [is] no longer in the home/ because she isn't/ safe in it."

With a new freedom of form that embraces the prose poem, *Saved By the Telling* aims sharp barbs at the discourse of violence and at the many varieties of female suppression: Picasso's woman ironing who is "still able to infuse domestic chores/ with a certain postural poetry." This collection also embraces the joys of female bonding in the wicked and warm "Apple Meditations: A Woman's Weekend."

Restoring the Wickedness strikes a delicate balance between strength and vulnerability. These poems courageously explore the ambiguities

of art and artists, treasure friendship, practice ecstasy and rejoice in the foremother who now becomes both myth and metaphor.

Wresting the Grace of the World is a reflective volume, a taking stock, a telling of the larger existential story. A marriage shudders, crumbles and dissolves. Tihanyi's poetic persona is thrown into a "persistence of vision…framed fate/ and the photographer's eye" where all is visible because it has become a construct of the creative imagination.

In The Key of Red (2010) is Tihanyi's most nakedly emotional book. Masks are off and filters down because Tihanyi's poetic force doesn't need them now. "What doesn't break us binds us" declares a poem about difficult love. This volume sings life's song in the key of red, as simply and spectacularly as autumn apples falling from trees, themselves a "calamity of red" but grounded. Understanding is acquired at great cost but has bestowed strength. Tihanyi's deeply moving meditation called "The End of Something," contains the words: "Finally it is the door that matters,/ not whether it is open or closed but whether you walk through it./ And you will, when love commands you." Having completed the life-altering journey of these poems, Tihanyi ends with one simply called "Beginning," in graceful deference to the cycles we move through and with the gently elegaic recognition that "everything falls."

The new poems that round out this Selected continue that beginning, as life and art flow on. Emotionally precise, clear, technically assured and imagistically apt, they follow the heart in a fearless voice that knows exactly what it must say.

—Patricia Keeney

On Reading Eva Tihanyi

And what is art
*if not a form of love?**

Eva Tihanyi teaches, edits, reviews, takes photographs and sometimes writes short stories. She also writes poetry with an artist's intuition and a scientist's clarity. She gives, in poet Donald Hall's phrase, "mouth-joy" to those who would recite or read aloud her medleys of vowels and consonants. From the time of her master's thesis in creative writing under the supervision of Alistair MacLeod in 1978, she has dedicated herself to the art of putting words into rhythmic patterns.

Each new poem in its undertow seems to murmur: *Start over. Begin again.* Tihanyi gives you desire in all its permutations, love in all its dimensions; she gives you lust and longing, departures, arrivals and new beginnings. She investigates the possibility, and limitations, of truth. She choreographs new steps in the dance of language.

Often she turns to the arts and to particular artists for inspiration. Monet, Picasso, Seurat, Kahlo, Faludy, Carson, Wright, Messiaen and a host of others have walk-on parts in her poetic drama. For decades she has been fascinated by M.C. Escher's image of a hand "drawing itself/into a hand," a "circle of creation." She underlines Gabrielle Roy's question reprinted on the Canadian twenty-dollar bill: "Could we ever know each other in the slightest without the arts?"

Tihanyi's unadorned lines address the human family: parent and child, self and partner, lovers, friends, dreamers. She speaks lightly on weighty subjects, touches and lets go, knowing that to be alive is to fall:

… the urgent apples
falling, the late October leaves
falling, brittle branches
breaking in the wind,
falling.

Sometimes she takes you to the edge of darkness and leaves you in mystery. The speaker in "Pier's End" walks to the end of the pier, past solitary individuals like herself and couples with dogs. There's an atmosphere of tense stillness, "…a stillness/ that cannot be measured." The city is usually visible from the pier, but not this time. The poem subtly builds tension and uncertainty in the reader's mind. When the speaker reaches "the pier's end," she thinks of Rilke "crying out to the angels." She ends the poem with two devastating lines: "A cry of the unsafe heart/gnawed by its own wild teeth."

Tihanyi's "The End of Something" in its freshness of vision and rendering cradles more of the real and the true than you'd imagine possible in a few pages. An *I* speaks to a *you*, an unnamed interlocutor, about *him*, a father. History, biography and memory entwine. Arguments flare between the speaker and her father, the speaker and the one with whom she is in dialogue.

The poet references the composer Messiaen who, in the *Quartet for the End of Time* in a World War II prison camp on January 1941, creates a music that is "a form of God redeeming God." The poem, much like the music, ripples through pain and loss towards something traditionally described as redemption. The arguments persist without resolution, without a winner or loser, within a tone of reverence.

The word *grace* recurs twice in "The End of Something," the word *faith* not at all; nevertheless, the poet has faith in her control of language. "*Poetry*," after all, "*is the language of belief in language*" and "even when we think art fails us, it doesn't fail us." In the midst of tension and

turmoil grace abounds, even the "hot grace that scalds the lips." Grace holds the speaker up through the fires of "The End of Something," and what's left, reminiscent of "Monet at Giverny," is "the vision/that never depended on the eyes."

If Susan Sontag is correct that photography is a way of seeing, so too is poetry a way of simultaneously telling and seeing. Many of Tihanyi's poems tell a story in a crisp, unsentimental way and concern themselves with seeing people and things, the self and the other, simply and profoundly. In "Separate Venues," for instance, the speaker tells a tale of distance between two persons while confessing an intimate revelation: "Fire has been my home motif lately—/ a place rather than an element."

"A writer's job is to tell the truth," Hemingway once too solemnly pronounced. Whose truth? Tihanyi's titles alone — her collection of short stories is called *Truth and Other Fictions* — hint at complexities that Hemingway airbrushes away. Even seeing yourself truthfully, never mind another, isn't easy. One of Tihanyi's narrators says, "Be who you are/ when you're not looking." But is there ever a time when you're not looking? Can you really choose not to look at yourself? The narrator's line implies a level of self-forgetfulness available perhaps only to children.

Tihanyi's speaker in "Five Facts About Photography" more accurately says,

Beneath every photograph,
an invisible caption:
Who holds the camera?

Truth within the human sphere is changeable and contextual. More often liquid than solid, more frequently shifting than still, truth "...is/ the ultimate shape-shifter." How it appears to you "depends/ on where you stand,/ and the light."At most you get "The truth of her/ in that moment." Context is always outside the frame "and there's no such

thing/as a whole picture." According to the Polish poet Czeslaw Milosz, human sight and speech "cannot encompass any phenomenon in its total roundness. The other side always remains in shadow."

Love is the bridge.

Love seeps generously from Tihanyi's poems — love for a child, a partner or a friend — but nowhere with such unambiguous affection as in the love of a granddaughter for a grandmother. Again my mind turns to Milosz, someone like Tihanyi with a central European heritage: "I think also that, could I start anew, every poem of mine would have been a biography or a portrait of a particular person, or, in fact, a lament over his or her destiny."

The first time I heard Eva Tihanyi read publicly at length was at the Central Public Library in Hamilton, Ontario, an evening organized by the Hamilton Poetry Centre several years ago. The last poem of the evening she read, almost recited, was "My Grandmother's Gloves." The gloves were the last thing the speaker kept in "the final detritus" when everything else was lost or distributed.

Left: these exuberant gloves
I cannot bear to part with

For when I slip my hands into them,
I am held, perfectly

The collection of poems entitled *Saved by the Telling*, which Tihanyi regards as her breakthrough book, is dedicated to her grandmother.

Love takes on many forms in Tihanyi's work, including the animal. When an animal enters a poem, take note. Bodies change into other bodies as in Norval Morrisseau's paintings. Consider the remarkable new poem "In Our Next Life" in which the speaker pictures herself and her lover as "wordless, blissful lions." They will meet again and "without

knowing it,/ recognize each other." Lion-love, unlike its human coun-
terpart, has no "fear of abandonment" and is "innocent of consequence."
Shared history is felt by a mere gaze.

Human love is more complicated. It isn't predictably recurrent like
the moon. It's often unrepeatable. And the love that memory doesn't
trap, as in "The Father Speaks," doesn't exist. When a father cries out
"I held your hand/ when you were too young/ to know it" there is no
way of knowing it because there is no way of remembering it.

In the face of inevitable dismemberment and forgetfulness, what
poetry can do, what Eva Tihanyi's poetry does, is put on record the
ephemeral nature of love. She bears witness to our longing; she re-in-
tegrates our brokenness.

—J. S. Porter

*Lines from Eva Tihanyi's poem "The Way I See You" in her book *In The Key of Red*.

from *A Sequence of the Blood* (1983)

Cascade

There is no beginning to this, no end.

The lovers
glued in their embrace
tumble slowly through the air, follow
the contour of the hill's curved green.

The sun is the only witness
to their tumbling

 her back, then his
 in endless succession

 the earth untouched
 but always there
 shaping their descent.

Below them
grapes sag on the vines, the field
shakes its mane of amber wheat.

The afternoon melts, has never existed.

Their closed eyes know only
the naked sleep of lovers

turning
the sky turning around them
beginning again.

A Sequence of the Blood

1.

The afternoon is a tremor of harvest,
an old October field gathers to erupt.

Soon: a swell of corn, ripe yellow
bursting through green skin.

In me, autumn also;
a last break of blood
before winter slows the world.

2

The stillness is a hoax.

Under the ice,
a steady flow of water, a flux of fins.

Smoke and breath grey the air
an vanish.

You watch and listen, know
that beneath the snow's calm
a dark spring waits to geyser.

3

In the deep blood
a tingle of rebellion,
a struggle of hot nerves.

Rocks heave, crack open;
in them flowers
burgeon upward like freed birds.

A celebration
the sweat of earth beneath new grass,
you upon me in the sunlit rain.

4

Everywhere the magic touch of light,
a summer brilliance
closing into evening

 until
 there is only
 the lush raven-feathered darkness,
 a promise of flight deep in me rising

 and somewhere between us
 a spark of stars.

Homecoming

Beyond this window:

> a tree-lined street
> leafed with autumn,
> a late sun trailing you home.

I imagine
the invisible boot-prints
of your walking, the warmth
of your sheepskin gloves,
the casual way
you brush the day into past tense.

I make coffee
in a season of magic,
this kitchen a garden,
the yard outside, a fertile room.

I must be careful with my senses:

> mocha mingles
> with the scent of burning wood

> the dim amber light
> with yellow walls

the oven's heat
　　　with cold from open windows.

I am within and without,
a secret ember fanned by the wind
into a hectic blush
yet safe
among the objects of this house.

When you enter
you will find the sun flowering
in all the shadows of my face.

A Housewife Studies Literature

1

She knows some men are dangerous
and that her husband isn't one of them.

In her sleep
she creates him again, a man sprung
from the darkness of her discontent.

She wishes him tall
and muscled with passion
breaking form the midnight garden
in long slow strides
eyes fixed upon her as she stands
waiting for him.

In the morning she sees him real
as he wrestles with the kids,
washes the car, adds link after link
to the only chain he ever weighed her with.

And so it is and is:
her days wake with longing,
close with words.

2

It is in books she finds the dangerous men,
the inhuman men who can triumph over pain:

>her husband
>as he lies next to her
>distant in sleep

>her aging face
>as she turns page after page
>and dreams.

Her dream
is the only chain
she ever forged
herself.

Myth

I empty the clay jar,
a ritual old as woman
repetitive as birth.

At my feet, a man's bones
and the skeleton
of a resurrected snake.

I mourn this curse
each daughter must inherit:
a dowry of vengeances.

Each her own betrayal,
her own clay jar
of bones, of snakes.

Transformations

There is so much about each other
we do not yet recognize.

You do not see
how gradually
with agile fingers
life weaves me together
strip by strip,
do not see
how I am becoming a paradox
solid and airy as wicker.

I, meanwhile, do not realize
that you are polishing yourself
into the warm luster
of fine stained oak,
do not realize
that you are softening
the rough edges of your strength.

Someday we will notice
these joint transformations.

I will run my fingers
across my desk
and it will be smooth

as the delicate skin of your back.

And you, you will sit
in your wicker chair
without worrying about collapse
and feel the wind sift through its pores
to caress your hair,
your neck's slight curve.

The Absence

Even as her tongue
answers the hardness
of his body, she senses
the absence;
yet reckless with lack of sleep
she rides him to release,
remembers how
he used to lie on her gently
like a snowfall.

She is a traveller
whose world has tightened
into one road, who conjures
mouth after mouth
to purge her of one-man loving

 yet holds him in her sleep,
 touches him
 from across the irrational distances,
 dreams of his return.

Fairy Tale

Once in the world
we were almost one,
the cool mystery of morning
upon us like dew,
our feet sliding
through the green mist of tall grasses
shivering in first light.

We searched for sorceries:

>among the bushes
>a sudden burst of lake,
>the unexpected child
>singing to the waves,
>a single bird
>high above the fields.

We revelled in myth,
renamed the flowers, praised
the birth of every living thing,
our joined hands closer
than skin on skin.

But the day spun us into night.

Soon we grew dangerous teeth

and protective scales,
became brutal and arrogant.

We stood apart in fear,
eyes honed to a sharp mistrust
urgent for answers,
the trampled grass no longer graceful,
the magic now of nightmare, not of faith.

There the morning found us
locked in tense despair,
silenced by a ruin
greater than our own:

 the death not of dreamers
 but of dream.

Solstice

She has lapsed into a callous season
empty of weather, sits in a weightless world
where the rain-burst dance she tamed
now tames her.

But there was a time when she lived,
a time when flesh was fury and poems were fever.

They kept her awake at night, fueled
fires beneath her bed
till her blood writhed with the wonder of itself
and she shot beyond the darkness,
a wild shiver of spirit.

In the morning, rain
steamed on the hot sheets, sunlight
fisted through the smoke to where she lay
still smoldering, and the world too
seized the wonder of itself.

Now she waits once more
for the madness she will always covet:

 to stand before the storm
 barefoot
 in a sudden mirage of words,

the whole world possible in words

to be
on paper
that graceful arching backward into space,
that woman facing east
touching the sand surface of earth
with the tips of her dark hair.

White Morning

She forges through the branches
hungry for space, an opening.

She is oblivious
to the small dangers of the forest:
 stones and crevices,
 broken leaves.

She feels only the muscles of her legs
tense and relax, push on
indifferent as the grass
 that accepts her footprints.

Again the lake
where she pondered the act of her drowning,
again the pull of wet bones as they bend
and she is drawn to the water.

A girl among the seaweed counts the fish
refuses to surrender her innocence
refuses to admit the fish are dead.

The dream clots
and she coaxes her feet
forward
 into a daybreak of words

intoxicating
as the scent of damp flowers.

Around her
fields of salvia quiver like crimson wheat.

She runs until she can run no longer

 falls

 with the heaviness of rain
 into winter armistice

 her selves in perfect unison
 a synthesis of snow on snow

 and as she wakes to the white morning
 she wonders what god called her here
 to confirm the world.

from **Prophecies Near the Speed of Light** (1984)

Arrival

1

Mud, vegetation,
air thick with heat and root smells;
and somewhere in the distance
the inching glacial tide.

Heat and cold share the earth,
the world a tactile paradox
only just imaginable
like burning snow.

At this moment,
in the heart of this beginning,
yours is a febrile serenity
a prologue to the dance of future legs,
of parts yet hidden.

You are a questing amphibian
poised on the border of two elements,
no longer in water, not yet on land.

2

A smooth panther glide

through the tricks of the forest;
you move by instinct
to appease your hunger.

Above you: a frail carapace,
layers of blue and white gases
in which the earth sits
indifferent as a stone.

Your strong legs
run reckless among rocks,
twist beneath your suddenly heavy body
as you stumble, falling.

You have no word yet for fate
or survival.

3

Cave eyes blink into light.

You study your hand,
its amazing thumb and fingers,
the way they bend, grasp.

You reach for a branch,
whistle it through the air,
swing it in arcs against the earth.

You beat the earth
until dust rises
and the sky echoes:
your first mirror.

4

It is the scythe you swing now,
the sickle.

You cultivate time, tame land
into neat rows, patterns of reason.

Impossible
to cast cloud-shapes into words
or paraphrase sunlight,
but you name them.

You ponder the wind's shadow
which no eye has seen.

When you cut your hand
you have a word for bleeding.

5

Finally you arrive

in the age of quantum,
of light-speed and cannibal stars.

Around you
the world webs its industry,
its net of self-deception.

You raise your eyes to the timeless clouds
forming and reforming above the cities,
watch summer freeze into winter,
white melt back to green.

You stand breathless
in the centre of the seasons
at the apex of a life.

Within you still:
a connecting flow,
the primitive pliant consciousness,
the focus, the birth.

The Heart as Lamb

The heart is a novice.

It has seen the wolf,
it knows the scent;
yet it continues bleating certitude,
grazing on the splendid world,
as if wolves did not exist.

The mouth, however,
is a different breed;
panic squirms inside it
like a trap-bitten beast.

While the mouth prays for certainty,
the heart eyes the wolf
and eats
and lives.

Blind Man

Since the eclipse, the earth
speaks to him in braille
and his hands listen,
his life syncopated
by the beat of a cane
tapping out anger, jazz, lust,
the rhythm of his breathing.

Light,
both particle and wave
falling and flowing
is for him a sound,
a white melody
scored on the dark sheets
of his eyelids.

He has a penchant for roses,
is the only man I know
who hears them sing.

Trance

The sky catches them in repose:
two magicians in a green labyrinth
drugged by spells of colour
and the ecstasy of wandering.

The stars settle at their feet,
fallen jewels, and light their faces
into vividness, the whole of them
present in the moment
like oceans in a raindrop.

Together they dream,
call forth every blue
hidden in the sea.

Theirs is the secret alchemy of love,
the true arcanum, all union possible.

In them wind sweeps into stone,
suns and moons rise and set in unison,
flowers find voice.

Time will seek them here,
hands joined,
singing opium red like poppies.

Night Music

Mystery
in dusk's undulating shadows
as they give way
to the raw song of the streets,
the unfulfilled motion
of a billion arms and legs
dancing nothing.

Mystery too, in the cosmic sieve
through which God's invisible fingers
trickle moons, planets, stars:
in chaos, a symmetry of grace.

I will never understand
the process of light-losing suns
as they shrink into black oblivion
or the city hum as it slows into silence.

Enough:
the curl of your arm across my breasts
as we lie here in the darkness,
two mortal moments
on a lonely spinning earth.

Solar Fugue

They say I wrestled with the sun;
I do not remember.

I do not remember
dancing on the threshold of a leaf
while the green eye of summer
looked upon me, saw me young.

I do not remember entering the leaf,
my diminutive green cathedral.

I was young once,
took for my talisman
a light that soared soprano,
shattered windows with its song.

I do not remember
singing like the light.

There is much in me
that has lapsed
into a colourless silence,
or sunk or slipped off.

Somewhere behind me
there is a love and a worship
but I do not recall the sun.

The Softening

Somewhere in this night
you wait for morning,
squirm under thumb
of dreams best left undreamt,
toss yourself finally into air
to see where you might land.

You land, a spider in amber
caught in airless solitude
hard as polar ice.

Someday perhaps,
even in your sadness
you will love the black wind,
the jubilant race of raindrops
down the window.

Someday you might not crave
an animal acceptance of fate,
no argument, no consciousness
but survival.

Perhaps then
the night will consent to silence,
and unafraid
you'll face the window,
see out.

Mutation

You feel your sex close,
your legs lose their lust for walking.

You are becoming
something earthbound and androgynous.

The moon above you, remote
in its borrowed costume,
is halved like a harlequin,
a light and dark jester.

You are in awe of its balance,
its cool celestial symmetry.

Yet you want to better the moon,
to eel your way through the streets
like a silver worm
burrowing light in all
the night's possible directions.

This is the aim:

> to shudder with light,
> to be within the world
> shadowless, moving.

Pendulum

For a moment you were the loud sun,
the burning zenith.

Now you arc
toward the cold moon,
the passive darkness.

You touch, merge,
but already
the movement back has started:
you are falling into light,
you are now a white place
where darkness dare not follow.

This too is momentary:
you blink,
slide again along the invisible line
toward night-side,
anticipate the instant
when you will be
the centre of the curve,
evenly divided,
complete.

Urban Spell

Around me the city clanks
like an officious machine
and in these confines of concrete,
among the live debris
and the delicate balances of love,
I polish the hard chrome edges
of a modern life.

But today, as summer
pushed its bright yellow face
through the kitchen window,
I ran to my upstairs room
at one with the awkward symmetry
of rooftops, and felt a celebration
of towers, bridges, roads –
the elements of reaching.

I grew light-headed as the sun,
something rooted in me
groping for sky, stretching.

Breaths Along the Run

1

Past the corner grocery,
the bookstore, the laundromat,
past all the necessary places
toward beach, toward water;
and in the aging afternoon
the clouds part like a great white sea,
the sky opens into sunlight
to reveal blue islands
high above the empty streets.

2

There are no ghosts
to haunt this happiness
this partnership of bones.

Centred in the moment,
arms and legs push against the earth
which holds everything in place,
pulls the pulse into itself,
a search for perfection.

3

God is but the speed of light,
unattainable.

Eventually, the body
must admit its limitations.

The face cools, whitens;
the lungs regain their quiet;
and she moves slowly
toward beach, toward water
like a figure in a dream.

An Instant Between Heartbeats

Sitting cross-legged in bed
naked against the large pillow,
I hold the moon in my lap,
a quiet silver cat, an oasis of light
in the cricket-throbbing darkness.

In my throat, a secret joy tightens,
pulls me into myself

 and I see the scent of lilacs
 purple in the valley

 I slide between rocks,
 thick shadows of rain

 while around me water
 webs upward through the trees
 and arcs of wind glisten.

I am slicing through time, through space,
a thin blade of spirit
unsheathed, unyielding, uncontrolled

 and suddenly I am an old woman

 I am the lilacs in the valley

I am the rocks and the rain

my blood webs upward
through the trees,
spills into the wind.

I know this will last for a moment only,
then I'll be with the moon again
and the night.

Autobiography

I refuse
the straight black line of rage,
the run of moments
not fully lived,
and even at the best of times
a fear of ends, delusion,
hardly a spin
on the carousel of morning
before God the barker
calls the next ride.

I am circling the world
like a moon, flaunting
my sunlit face, my roundness
above the flat blue plane of sky.

I refuse all other geometry,
vow that in the end
mine will be
a long pure spark of waking
eye to eye with the stars.

Nearing Thirty

I've ridden the dark cascade of youth,
have followed the cold spring water
into caves and crevices,
have broken myself on rocks.

I have been where every woman goes,
have wrestled with the shape of earth,
have been smoothed and rounded.

Now I am stepping into summer,
the white eye of the sun.

I have reached the full season,
have sorted through
and know what I must save.

If choice is mine
I will take the tall soul of the tree,
the pen's blue dance,
and you, for whom I choose to write
about tree-souls and dancing.

Death by History

In this country
where proper funerals are still customary
no one believes in radioactive graves,
corpses massed in mounds.

War's rude manners
do not spoil the meals,
interrupt hockey games,
intrude upon cottage weekends.

History happens elsewhere,
is complained about at parties
alongside the price of foreign wine.

But lately death by history
doesn't seem a far-fetched thing.

Rumours rob houses of the their complacency;
acts, of their casualness.

The police are helpless to stop them;
the government has no comment,
is secretly studying
the survival of cockroaches.

And everywhere

dusk thunders into wind
as *Zeitgeist* rides
the Trans-Canada toward Vancouver,
looking for an edge, somewhere to end,
while prophets hide their faces
in their hands, peek
through parted fingers
at the long shuddering darkness.

Prophecies Near the Speed of Light

1

She runs,
a long shaft of darkness
ahead and behind her,
walls on either side
and everywhere
the gnash of teeth,
the slap of feet on stone.

This is the final running:
the heart swelling with sleep,
its last red protest
eager to jostle the galaxy,
the infinite complacence of time.

2

Faint memory:
thin blue breath of morning,
the sun's blonde tendrils
curled on spring horizon,
the voice of her garden
as it calls to her

and she comes bearing seeds
and the first song of birds.

3

As dying metamorphoses into death,
so she becomes her last face:
a turbulent mask, a thrust of light;
and when all thoughts cease
her eulogy will be a howling green
crashing through
the silence of stars.

4

In the dusky corridors
of a time before night
she walks alone in silence,
her winter face a eulogy to summer
as she brings her wasted girlhood
to the sea.

But the strength grows in each step
toward the dark horizon.

She learns laughter, vows ecstasy,
gathers pebbles, shells, grass,
the invincibility of earth;
and finally, wholly filled,
burst forth again – a child
running green upon the streets,
in her a woman
breathing a greener grace.

from **Saved by the Telling** *(1995)*

Saved by the Telling

We're sitting over coffee one evening, my friend, husband and I, when her boyfriend phones demanding to know where she's been all day. When she tells him she won't answer to anyone, he slams the phone down, screeches five minutes later into her driveway. He doesn't wait for an invitation, rams right in.

He yells, she yells back, they have it out. My husband and I remain silent, are sudden statues, backdrops to the argument – though the men, I sense, are ready. Attack, defend. Two sides of the same male hand, women at its mercy. Always.

Before a woman dares open her mouth to a man, she'd better learn alternatives to words. Inevitable that he'll want to shut her up, one way or another. But she'll keep on saying anyway, in other ways. Will be forced to remember Philomela's pain transferred onto tapestry: art fueled by the absolute need to tell.

Film Clip

You see him stop for a moment.

It might be over, hope it's over,
but then he comes at her in the bathroom,
they are both naked, they should be making love
but instead, in a parody of childhood games,
he smashes her with a pillow,
shoves her against a wall.

And then she's down
cowering beside the toilet, her hands
raised to protect her face, whimpering
Don't hurt me, don't hurt me
as if the words
could ward off evil, call off
the mad dog in him –

What happens next
depends on how much faith you have
in words.

A Simple Poem for Naomi Wolf

In memory of Bronwen Wallace

This started as a simple poem for Naomi Wolf,
you know, the kind Bronwen wrote Virginia, the kind
women write to women they admire.

I, too, wanted this simple, wanted
to forget about the hair in the sink,
the pervasive stench of cat shit.

Didn't want to think about the laundry
or the bills or my son's sore throat.

Wanted to talk about how much had changed,
how we had traded victimhood for power.

I wanted with all my heart
to see the wine glass half full
instead of half empty.

But somehow I kept coming back to them,
the small details that suck us down like quicksand,
the daily mud we battle through.

Kept remembering my neighbour,
house for sale, telling me about her husband.

Couldn't get her voice out of my mind,
a voice explaining fear, the impossibility
of arguing with a fist.

I kept coming back to it,
this corrupt version of progress:
a woman's place no longer in the home
because she isn't
safe in it.

Irony

Picasso's woman irons,
gravity incarnate, pressing her weight
against cloth, against
the creases of living.

He painted her when he was a young man
in Paris in the spring.

She too is young,
still able to infuse domestic chores
with a certain postural poetry;
still able
at the farthest edges of her naiveté
to imagine Picasso
ironing.

Picasso Meets Dora Maar at Les Deux Magots

This is how he first sees her: she's sitting with friends at her favourite café, throwing her wit around, a tense weight. She places her left hand, fingers fanned, on the wooden table. Drives a knife between her spread fingers, moves methodically to each new space. Time after time the blade thunks down, often grazing flesh, until blood blooms across the pink roses on her black lace glove. She continues, not out of boredom or insolence but need. She would like to photograph this if she could, his eyes as dark as hers, skewered to the scene by an invisible knife.

Olé! she cries, both matador and bull, victor and sacrifice.

Breakthrough

After reading the journals of Sylvia Plath

You once thought of him as a fawn
but he turned satyr;
horns rose from this head
and he gouged your heart with them,
bucked you to the wall.

Now, in his absence,
you fill your heart
with a violent cacophony,
vow to give it form.

It will be a tryst
between you and the words,
the final love affair;
you will press yourself into paper,
your blood will be the watermark.

The night stares at your hand
through the window, moves closer,
a black fox.

You gathered yourself
together for this;
you have been waiting, building

all your life this complex sepulchre,
this hymn for your heart's
last
mad-muscle dancing;
and as the blood
ascends to its flowering,
you throw your fist into the page

 which sings at last as you willed it:
 a bludgeoning thunder
 echoing in frozen snow.

Glass Heads

Years ago, when we happened upon
that shelf of glass heads in a Yonge Street store,
I had a flash of recognition, knew such a head
would be the perfect gift from a woman to a man:
see-through, smooth and breakable.

You agreed, and we each
bought one for our husbands
so they could watch what they imagined
were our dreams.

Not unlike the fishbowl concept we remarked
or perhaps a miniature shop window;
it might keep them out of trouble,
would certainly keep the focus
off our real heads, the subversive ones
with their thick tangle of hair
and female synapses.

We thought of it as simply
heading off trouble.

And our husbands, both avid collectors
of unusual gifts, were grateful recipients;
spent many an hour staring through the glass.

Odd though, isn't it, how you and I
have carried the glass head, its image,
with us all these years;
have admired its green hue,
its weird opaque transparency;
have felt compelled
to re-imagine it in words:
ours,
or theirs?

Apple Meditations: A Women's Weekend

1

Why we five have gathered here:

To celebrate the circle.

To be, for a time,
seeds of the same apple.

2

We read the runes,
recognize importance,
drink from blue goblets
the colour of healing.

It is the apple season,
the time of completion.

We see what we believe,
and believing is seeing.

3

A round-table lunch overlooking the vineyard and then the drive

home, all of us giddy and exuberant and abundantly daring. Which is why I'm in the mood to pick apples, jump out eagerly as soon as we roll to a stop by the orchard. Why, grinning like some latter-day Eve on freshly released endorphins, I ignore the NO TRESPASSING sign, pull five apples from the bountiful branches. No snake in sight, no Adam either. Just Eve and her friends, a party, apples for all.

It has to happen though, it is inevitable, the black car that brakes to a halt as Eve, apple-laden, runs across the road. God has arrived, perfectly punctual, just as nasty and humourless as always. "Can't you read?" he says, belligerence his obvious strong suit. Eve is promptly accused of theft, and payment is demanded. He wants a dollar, she gives him two, and the matter is settled, God (as usual) getting twice as much as he expected.

4

It is fall equinox,
the day of half light and half darkness.

We sit in the kitchen around the pine table,
five women sculpting goddesses, goddesses sculpting,
while the apple-scented candle burns
and the harvest wine sweetens our tongues,
warms our fingers as they work the clay.

Wonders are forming, evolving
in the urgent silence of our shaping hands.

As the sun travels south

across the celestial equator,
so too we head down into heat,
the gut energy of creation.

What we make is who we are
in the making.

5

Sunday morning, a final pilgrimage,
five pairs of heels
clicking along the hospital hallway.

We bring our grandmother an apple.

It is an offering, fruit of our hunt,
taste of our triumph.

But it is she who gives us the greater gift,
the last words in our communal journal:

> *Love one another*
> *Trust in one another*
> *Do not forget me.*

Wholeness, closure,
the Goddess's immortal heart;
a blessing.

Growing in the Realm of Saturn

In the hospital room,
an efficient, electric quiet:
the hum of clocks, lights, furnaces,
all mechanisms working.

It is November and raining,
a myriad greys window-framed.

Amid the odour of uneaten meals and urine,
an old woman lies, softly breathing.

Through no fault of her own
she is not who she is.

Not the woman you know,
have always known: strong,
brimming with will.

Her inertness betrays her: impostor.

And it changes you, the terrible knowledge,
when you recognize yourself in her, discover
the ending which belongs to both of you;
admit, finally,
that breathing is not living,
no.

Analogue

My mother bleaches her hair
in a one-room flat
while her Danish Modern furniture
rots in her landlord's garage.

She is cracked like a mosaic
left too long in the fire,
hers a decade of piecing
parts into the whole,
the whole into its parts.

And through the long slide down the years
no one knew, will ever know
my mother's dreams of cold, of snow.

My father, greying at the temples,
is thinner than he used to be;
his hands with their immaculate nails
rest in his lap like sleeping children.

He is worn as a slipper
and shaped to a second wife's foot,
his a decade of shuffling
over thick suburban carpet
in over-heated rooms.

And through this stifled blaze of years
how he ached for cold, for snow
no one ever knew, will know.

My Mother Turns Fifty

As another year of silence
falls from the calendar,
I imagine her exploring malls,
reading cheap romances, staring
for hours at air, photo albums,
the drafting degree
beside the welfare cheque;
imagine her taut gaiety
braced for breaking,
her body fat with boredom
massed in front of me,
obstacle, reminder.

Ten years since he left
yet love for my father
still ticks in her heart
like a perfect clock,
timeless.

I imagine peeling
the decade from her face,
finding her as she was
and somehow understanding.

You Wondered How

You wondered how it happened to your mother;
now you're finding out.

It starts with the way the table
suddenly taunts you with its massive wooden insolence
and you realize you've grown separate,
breathing through the days like a wingless moth
still and silent
save for a heart tolling
against stillness and silence.

It continues when in the bath
you notice your winter-pale thighs, unsightly logs,
heavy beneath the water, your whole body
nothing but weight, mass,
the solidity that keeps you here
working backwards from death:
the point of departure, the given.

But it is the ride to work that truly frightens you,
the way you find yourself
laughing along with the woman at the back of the bus
for no reason, every reason, laughing
like your mother the day her divorce
arrived in the mail: laughing.

The Child Eventually Grows Up

At six months
you tossed me into my grandmother's arms
like a basketball to the nearest teammate,
then ran from the court.

The two of you – my mother, my father –
in your hopeful daring twenties
hay-carting across the Hungarian border
in the January night.

Too much risk with an infant
you thought, and we all survived.

Six years later
you collected me at the airport,
a long-lost suitcase, contents
not remembered.

What you found was, in your view,
mouthy, clumsy, undignified;
a child in need of lessons.

And so you forced me to the top bunk
to cure my fear of heights,
cut my hair short enough
to ensure it could no longer hold

my grandmother's ribbons
(you said I needed style).

I was not like my four-year-old brother,
by birth an instant North American kid
to match the Campbell's soup,
the chrome and plastic furniture.

What I was you did not want –
a small self
flying open-souled and curious
to her faraway fairytale parents
who now expect
all they could not give.

Naming

1

The window frames a blue pause
in the run of winter:
clear sky, the snow
embossed with faint outlines
(buried branches, rock tips).

Before your eyes, falling:
the domino line of centuries,
time sweeping backward
to the antediluvian world,
the cave in winter.

Here, under your blanket
of tumultuous hair,
you are animal, and woman,
urge incarnate.

The child who gasps first breath
between your thighs
is unnamed and ageless,
body of your body.

Already, death blooms within him,
certain flower.

Safety
is not knowing this.

2

When you return from the edge of yourself
to your own time,
the warm wood-glow of the sideboard,
the cats dreaming cat dreams,
your son, five months old,
is cooing his marvel at the plastic rabbit
in his hands.

This is the familiar life,
the comfortable evolution.

The lines around your eyes
grow stealthily more pronounced,
your hair greys.

The days are more and more a recognition
of these and other things, all carefully sounded
like the child's proud verbal pointing:
apple bubble face.

Names occupy the world
with the assurance of buddhas,
meaningful and placid,
each a soothing roundness
complete in itself,

each word a hologram, in each
the world recreated.

You summon it now, your son's name,
that small melody.

Brendan, you say,
and know that in the saying of a name
is born the first danger.

Rare Language

Beneath the headline:
a picture of Tevfik Esenc,
face deeply furrowed as plowed land
but jovial above the suit and tie
donned for the photographer.

There was a time
in the Caucasus valleys
when 50,000 spoke Oubykh.

Now there is one:
Tevfik Esenc, Turkish farmer.

On his tongue alone
the 82 consonants, 3 vowels,
of this sound symphony;
and when he dies
yet another silence will gap a world
gouged already with extinctions.

Here, too, languages dying with farmers:
the beaten fields fading
and in them, the weathered cry
of failing barns.

Losing: the vernacular

of clean distance, cattle brawn and wheat sway.

Eventually, headline and picture:
the last Canadian farmer
speaking farm.

Accidental Roommates

1

At dinner you say nothing,
yawn, look tired,
your silence an aggression
I defend against.

When conversation does burst from you
it is in sporadic volleys, word explosions.

After midnight, in the hotel room
we're like girls in a dorm
drinking Cokes, swapping stories.

You say you're tired of smiling
at the wrong people at the right time.

You say people wear you out.

What you don't say:

> that there's a toughness about you,
> an arctic resilience
> like that of the lichen or the dwarf pine,
> and you like your eyes open
> no matter what the landscape
> or the weather.

2

We progress to next day's lunch.

You spoon your way through soup,
talk about death and displacement
in their personal forms.

These are not elegant stories.

They have the force of a heart
stopping on a strange street.

The most you can do is tell me;
the most I can do is listen.

3

After lunch, you take photographs:

> a barbershop, the barber
> shaving his own face,
> embarrassed though laughing
> as you aim the camera;
> he jumps behind a partition,
> refuses.

You are like the barber:

>you laugh and keep moving,
>do not surrender,
>not even to poetry perhaps.

There is always the mythic train to catch,
northbound

>except your train
>moves on solid tracks,
>and it's no myth
>that between taiga and tundra
>stubborn trees survive.

What I Think of When I Make Love to a Man

Not England, ever;
Greece maybe, or Spain – hot countries
where passion flourishes like the sun,
fans out exultant as a peacock's tail.

Occasionally of others
but that's mostly for revenge.

And when I'm serious,
of Kafka, how the body moving against mine
might be transformed by morning
into a controversial insect.

What I think of when I make love to a man
is not necessarily what I want to think of;
in fact, it would be preferable not to think at all,
the not-thinking an erotic white noise
to fill the space between breaths.

Lately though
my thoughts have taken a different turn:
there is a suitcase on the bed,
and I'm packing the vital signs, including
the heartbeat, the silence after it.

Leavetaking

There's warmth in October,
a peculiar burnished light
that gilds trees, buildings, roads
with the glow of ancient trumpets.

In this light
the world is eternally possible,
the opening and closing of distances
simply a matter of time.

Mere days ago
you said you could picture
exactly how the airport would look,
afternoon sun falling through windows,
milling bodies
waiting for the boarding call.

You, too, are familiar
with the myriad locations of goodbye,
the countless individual histories
reborn in these gestures:
hug, lifting of suitcase, final wave.

The escalator takes me up,
light already shifted.

You wait, coffee in hand,
coat open, backlit as a photograph

 and I see you still
 because vision persists
 though reality moves.

Midnight at Lucci's

Outside, the sky expands and contracts
like a great slow heart,
the windows around us, dark screens
on which potentials
cock their heads like deer,
pause.

We linger over last drinks,
complain of the times we are ordinary
in an ordinary world

 and the raw eclectic life,
 domesticated, well-done to boredom,
 petrifies: hard
 to suck ecstasy from a stone.

And though season after season
a wild hope guides us
to books, friends, foreign lands,
in both of us
a fear breathes, deeply
like a hunger:

 that years from now
 (our bodies no longer strong
 or fashionable, demanded

or demanding) only our eyes
will hint at what we are tonight:

young, charged with a peculiar beauty,
speaking of the cordons
through which our possible selves glide,
composed and sunlit, undulating
towards the sea.

Inside

It is always February,
wind attacking branches, toppling
the snow from them,
coup after small coup.

The heart is weather bent;
sways onward, a lost ship
ricocheting among the ice floes;
dreams of Van Gogh's ochre fields
where sunlight always happens.

If happiness is sanity,
the heart vows to be happy.

Combustible, stoked with joy,
it eagers skyward, longs
to be yanked into a high place
with the sun.

But the body,
both prison and prisoner,
binds, is bound.

Sanity, sanity hums the frustrated heart
as it dreams its balustrade of light,
the slide upward;
imagines itself, finally,
lifted free.

Escaping Hypnosis

You step into happiness eagerly
as if it were a scalding bath in winter,
welcome and luxurious.

The days pass on,
smooth as water, elusive as mercury,
wearing away your necessary edges,
washing over you in steady currents
as you lie motionless
in a fabulous absence of pain.

You are speechless,
though a question mark
curls like a serpent
in your apple-scented throat,
winds gradually
into your silent core;
but the warmth lulls you
and you do not move.

It is easy, this immersion,
like drowning.

It is only your hand that can save you,
your hand which happiness cannot alter,
which reaches out into the shock of air

and listens,
poised to record
on a seemingly empty page.

from **Restoring the Wickedness** *(2000)*

Mixing the Myths

1. Nutritional Advice

Baubo the Belly Goddess
in all her ribald splendor
plants herself roundly before Eve
and says:

Adam is a carnivore
though he doesn't know it yet,
but you're a vegetarian;
stop trying to be like him,
eat the apple and be nourished.

But what about Adam? asks Eve.

Baubo looks her straight in the eye.

Let him eat snake, she says.

2. The Dawning of Consciousness

The beauty myth starts early,
back in the Garden
when Adam and Eve get jolted,
become suddenly aware

that fig leaves might be necessary.

Adam, instantly critical
(this is, after all,
before the Men's Movement),
takes one look at Eve
and complains to God
that she is less than perfect
and what's the problem up there anyway,
has the Old Man lost his touch?

At first all Eve can do is blush.

Then the apple takes effect,
and she wakes up.

3. Apple Appreciation

Intriguing, the apple;
so ripe with good and evil,
neither good nor evil.

Although the serpent
steals the show, has the best lines,
the apple is more interesting,
a token fruit, small
but consequential.

Yet no one pays
much attention to the apple,
how it felt in Eve's hand,
how it tasted on her curious tongue.

And in the chain of blame
from Adam to Eve to snake,
it's surprising
the apple hasn't been accused –
simply of being there.

4. Adam's Version

In the beginning, he is everything she wants, but she can't leave
well enough alone, starts tampering. Like a child with a paper
cut-out, she dismembers him: creatively and with good intentions.
At first the legs are too long, then the arms. Then the torso is too
wide and the head too large. More trimming, but the legs aren't
even. Soon there's nothing left but the box in the middle, the
essential square.

She mutilates him over and over, without thinking. For a while, she
is fortunate. Each time she cuts him down, he miraculously sprouts
new limbs, regenerates like an earthworm. But eventually, he can't
grow whole. His arms and legs stay stumps; his head emerges only
partially, a half circle.

No wonder he can't trust her when she puts the scissors down.

5. Eve Prepares for the 21st Century

She needs new shoes, shoes
that will truly fit her.

Running shoes
that honour Nike, that promise
the will to do it
whatever it is.

The bland sales clerk, oblivious
to the myth now in progress,
asks what size.

What she wants to answer:

Ask not what size shoe.

Ask what size victory;
what size wings.

Lilith Takes Up Residence

Lilith, having grown tired of the desert,
decides to try Toronto,
see how the sisters are doing.

And what better way than as a Barbie doll,
perfect disguise for a bitch
in a culture where
a Being In Total Control of Herself
is still suspect.

So she arrives, accessorized to the hilt,
with talons and wings, owls and candles,
enough attitude to scare the Devil himself.

An in-your-face Barbie
terrorizing department stores
in her *Better a bitch than a doormat* cape,
inspiring little girls of all ages
to be just like her.

And Ken, poor Ken;
he suddenly grows genitals,
wants to get on top,
but of course she won't let him.

Barbie's Father Has a Nightmare

His daughter, now forty,
decides she's had enough,
calls a press conference, announces
that like Xena, she will be
a figure of action, a warrior princess.

Put simply, she wants to kick ass,
chide the gods as if they were
delinquent angels, predictable and delicate,
prey to her uncanny prescience.

She wants to ditch Ken and teeter
on the highest ledge of pleasure,
dare her newly appointed heart
to commit a fall into erotic turbulence.

She wants to indulge in choices of all kinds,
slide into black leather if she feels like it,
spike her hair, have Midge's name
tattooed on her breast, sport
an Athena countenance
as a conversation piece.

She wants to dance with turpitude;
relish it.

At the Bar: Girls' Night Out

Eve admits she's still
brooding over Adam, living
with her legs open, eyes closed,
mistaking blind sex
for blind faith.

Persephone says she's finally
in love with Hades,
but he's no longer interested.

Lilith downs a shot of tequila,
stays silent.

Eve complains
she's bored with Adam, needs
more humour in her life,
more conversation.

Persephone, near tears,
worries that *Hades* is bored with *her*,
doesn't know what to do about it.

Lilith says this is why
she likes to fuck strangers.

Lilith Re-converts a Former Lover

She arrives unexpectedly
though I have been vigilant, forgetting
her body over and over, the way
it pushed against me,
pulled out lust, a wet spectacle
(that, too, unexpected at the time).

She's dressed in black as usual, leads me
across the bar to temptation,
and by the time we reach the farthest booth
I'm already beyond saving, have succumbed
to the onslaught of desire, the decadent sway
of her criminal hips, oh such tight denim.

We slip into the dark corner, she into
my darkest recesses with her indigo eyes,
her gaze a silent erotic requiem
for all my safe loves, my havens of virtue.

She is not safe, and I'm not sorry;
if this is damnation, then I'm damned,
an unrepentant reprobate.

Lilith's Song

Ravenous for self
as the raven is ravenous,
you are patron of chaos,
force of blood beckoning.

Goddess of lust,
purveyor of wickedness,
you are the hazard,
the pre-guilt rogue element.

Mother of demons,
lover of night boys,
you are the shadow
and wholeness demands you.

Language Lesson

Surrender: sir-end-her.

Homage: what is given to *les hommes*.

Irony: nothing to do with shirts or mining.

Common knowledge, that linguistic nuances
complicate matters, break
every story into multiple versions
all of which are true and false,
both and neither.

What is less obvious: the process,
why we choose what we choose.

Why, for instance,
we prefer *nude* to *naked*
or *lust* to *desire*.

Why a man will call a woman
dear or *ma'am*.

Why he might say *slut* or *bitch* instead.

What's interesting
is not so much the word itself
but the reason it was picked.

George Faludy's Living Room, circa 1986

In a Toronto high-rise
the poet sips tea,
his bold white hair
electrical as Einstein's.

Next to his armchair: a live tree,
leafy and unexpected,
green with braggadocio
and brimming with finches
– sixteen in all –
that swoop and climb,
alight
on the whimsical branches,
try their song
against the walls.

The Birth of Frida Kahlo

This was no immaculate conception;
it was messy and painful,
blood-bound from the start.

Now, the miraculous coming:
I feel its will shifting inside me, sense
its animal hair and pagan teeth.

I fear I might not survive
this newest advent of myself,
neither humble nor reticent.

It does not falter nor prevaricate
as it rips its way forward.

When its head appears,
it is serious and smiling.

Renaissance Masterpiece

That's what she's become:
a piece of the master.

Lisa del Giocondo, "La Gioconda,"
a Florentine merchant's wife,
the most famous
of all the canvas girls, her smile
a testament to the human heart,
its sad, equivocal whimsy.

Leonardo, who loved her
best of all his work, infused her
with paradox, a sensual *sfumato,*
light and dark ambiguous,
forever intriguing.

Now captive
behind a bullet-proof screen,
she is a museum prize, icon of centuries,
a priceless face for viewing only.

Imagine her then – and your surprise –
when she rises from her chair, shifts
out of pose, leaves the frame
frowning.

Janis Joplin Would Have Loved You

Between your thighs:
horses, motorcycles, men.

Behind you:
the hearts you've won and tossed,
their metronome devotion
still ticking.

You abhor such smooth monotony,
demand a music fast and improvised,
tempting and savage.

You're tall and unpredictable;
no one's going to talk you down.

Idiot Savant

He knows every position, every aid;
has memorized *Gray's Anatomy*,
The Joy of Sex and the *Kama Sutra*.

He can name every bone and muscle,
recite treatises on the nature of breathing.

His textbook definitions are impeccable.

He can calculate excitement,
calibrate the heart.

His precision is renowned,
his ability to arouse the body notable.

When it comes to sex, he's a human hyperbole,
the perfectly perfect lover.

Too bad he's no art and all technology,
weak on nuances, low on imagination.

Perhaps if he learned Shakespeare,
he could interpret your eyes.

Kissing

My grandmother's first boyfriend
was a blond, blue-eyed boy
with lips as smooth and sweet
as caramel.

They'd go often to the train station
so they could kiss with impunity –
no neighbours, friends or parents,
just a station full of strangers
smiling at the two of them,
young lovers in the embrace
of greeting or goodbye.

My grandmother laughed
when she told this story.

*Anything is acceptable
in the right context,* she said.

Remember that.

The Stuff of Legends

My grandmother and her friends,
all talk and teenage bravado,
laugh whenever they see him:
a trench-coat man
flashing women in Heroes' Square.

Except my grandmother,
who likes her words spiced with action,
decides one morning to maze her way
through the seemingly oblivious bystanders,
set on a course directly toward him.

What happens next I can only imagine:
his startled look
as our heroine marches fearless,
determined
to flash her daring in his face.

It's obvious
she'll grow to be the sort of woman
certain women frown at
and men underestimate.

Imperative

My grandmother lives out
the end of her dying.

I swing back and forth
between you and her,
between the body's lust
and its demise,
the imperative of the body
either way.

The cruel air of the hospital,
the smell of semen on my thighs.

There are many forms of love,
and each one is the hardest.

My Grandmother's Gloves

Even her gloves revealed her: soft leather,
not a common black or ordinary brown
but a deep flamboyant orange,
the rust of late autumn, warm and supple.

They are the last things I have kept,
the final detritus after all the givings-away,
the ritual removals:
buttons in plastic pill containers,
assorted remnants of cloth,
zippers, needles, thread;
her clothes all gone,
her furniture distributed.

Left: these exuberant gloves
I cannot bear to part with.

For when I slip my hands into them,
I am held, perfectly.

Grandmother

I want to restore you
to your wicca-dness,
your crone shape
pulled from the depths.

I want to release you, shadow ally,
from stoves and dishes,
irons and needles,
the domestic domain
of your surface self.

You were always a sly one,
beneath the daily tasks
a tamer of wisdom.

You are now my myth
and my metaphor,
a bridge between
my face and the mirror,
the mirror and my soul.

Beginning at Zero

Zero is the most difficult number,
indivisible, heart
of all direction.

Bring me zero
and I will show you a round riddle,
the hole into the looking glass,
everything and nothing;
an oasis of containment,
empty.

Add zero to any number
and both it and the number will grow;
subtract zero
and it will make no difference.

It even appears in *love,*
and *fool* has two of them.

Fool's Journey

Bliss colours the fields, and I, holy buffoon,
am improvising life, its song of amazement.

To sing is to master the fear;
to sing is to own the desire.

So I walk on through the light that golds the green,
joyous in my momentum, my unrehearsed singing.

Around me: vines weighted with grapes,
trees festooned with apples,
the sky a triumphant blue.

What has happened or will happen
is not what matters.

Close your eyes and picture the world.

If you can't imagine it,
it will never be yours.

Harvest Moon

Every year
the vivid harvest moon
(no less mysterious
though men have walked on it)
lights the grape-heavy vines,
the apples on the verge of falling.

In this moon's light
the world is less afraid;
the night cannot assume itself.

I'm reminded of you:
how you, too, light
whatever comes toward you
even if it's heavy
or on the verge of falling.

How when I draw near
I'm less afraid; for a moment
light as light.

Sun on Water

Always
yours is a journey of engagement,
the "gorgeous fever of consciousness"
soaring within you, your breath intoxicated
by the scent of sun-warmed cedars,
your step marked by stones
pressing the soles of your sandals,
your ears tuned
to the hypnotic rhythm of light on water,
music made visible.

When finally you pause,
you are fully in the moment;
momentous.

Watch for hours as light
(original genius)
improvises on the river.

Stand mesmerized into wonder,
your eyes welled with sight.

Word Play

My son, in third grade, is collecting nouns;
has decided he likes them.

Giggle of geese, he says gleefully;
snide of lions.

Herder of crows, I add, catching
the spirit of the game.

Then, because I've always been prone to puns,
the worse the better, I command with mock severity:
Now let's play havoc.

How do you play that? he asks,
intrigued and willing.

Very carefully, I joke,
tickling him to laughter.

What I don't say:
Ask God; he's the expert.

First Friends

On a whim, I dig out the photo album,
the Grade Two class picture,
(black and white in those days)
and sure enough, there we are,
friends already
side by side in the front row,
locked into pose:
hands clasped in our laps,
feet crossed at the ankles,
both of us squinting at the sun.

I don't remember this picture being taken.

My earliest memory of you happens after school,
in your basement, in fluorescent light,
cool below-ground air.

We play Beatles singles on your record player,
dance around the room and sing accompaniment
till from upstairs your mother hollers *turn it down*
and we giggle, pretend not to hear her,
while "She Loves You" accosts the walls
yet one more time.

I look again at the picture,
your small smile, my wide grin;

wonder what moments live holographed
in the archives of your memory,
pedestalled to perfection.

Imagine our child songs still sweet in us
though we're both past forty now
with children of our own,
teenagers in the basement
blaring their rap CDs
while we worry about them over coffee
at our respective kitchen tables.

What We Take With Us

My son plays soccer
in the summer rain, runs
across the keen grass
with the ardour of his age:
almost ten and timeless.

Mud sticks to his cleats,
socks to his shins: his uniform
is soaked and clinging.

Years from now
it's not the score he will remember,
nor whether he lost or won.

What will remain:
the smooth wet nylon
against his back, the cool rain
on his hot face,
the power of his foot
connecting with the ball.

Elk Lake Revisited

When we arrive, there's a fire
raging behind Grady's Tavern.

All afternoon it has been raining
but the flames continue, unappeased.

The bar is empty,
the patrons gone either to help
or watch from close range.

Tired from the long drive,
we nurse our beers, admire
the smoke's wistful beauty
below the lace valances.

I wonder if the head
is fooled sometimes, you say;
we come back to a place
and it reverts us.

I think of alchemy,
fire and water, transmutation; us
suddenly twenty years younger, reverted
by the simple act of being here
in this pared-down northern landscape.

Memory is fickle, chooses
its moments at random; presents them
like water-perfected stones, surprising moons
among the dark debris.

What we remember ignites us;
and like the phoenix
we burn down to what was
so we can re-invent what we'll be.

Pearl

It begins
with something miniscule but foreign,
a grain of sand perhaps.

The oyster wraps the irritant
in layers of nacre,
continues this defense
until the granule is transformed
over time
into a soft gem, round and lustrous.

It grows, a stone like no other.

The earth did not conceive it;
heat did not harden it.

Its light is warm,
its body smooth and self-contained;
it has no sharp edges.

The surprise of relationship:
intruder as stimulant,
oyster as creator.

You as particle around which
something lovely in me forms.

In this Dream

In this dream it is September,
a slow-motion afternoon, the two of us
sipping Merlot in the vineyard,
our heads sun-haloed, knees touching
under the weathered oak table.

Around us, crisp edges of colour,
vines brimming with green,
the eyes of animals vivid
and discernible, in everything
the wild apparent.

I reach over, guide your hand
across the smooth tablecloth,
teach its delicate braille
to your fingertips.

Far away in the nearness
a bird warbles.

Such focus, your eyes,
dark mercury
fluent with desire.

You are safe with me.

All I want
is to astonish your body
with love.

Hands

1

It: the universal pronoun of everything.

She's not sure how it happens
but it does.

She gives birth, becomes new,
a fresh version of herself
moving in a world more dangerous
yet more beautiful
than what it was.

She balances lightly
along the invisible seam
between thought and word,
becomes once again
conscious of amazement.

Is amazed by what
she still feels for him,
how in the beginning
she wore his dark love on her throat
like a cameo, like a hand.

Now loves him more deeply
though depth is not always passion.

Recognizes
that if this is a sadness,
so too is love.

2

Wonder: August,
lush and muscular,
clouds moving
against a plum and sinew night,
air heavy on skin,
palpable.

She rolls it silently on her tongue:
plum and sinew, palpable
her mind pliant, plying through words,
hand through fur, feet
through long, soft grass.

He stands by the window,
arms crossed, hands hidden.

Dark sky, he says.

Rain.

3

She waits in the cooling dark, watches
the clouds give way to stars, envies
the cat curled against his heart,
its trust instinctive as purring.

It takes the warm rhythms of his hand,
gives back its pleasure.

She, too, used to be able to do this
freely.

In his hands she was a homecoming,
soul and body one.

Now there's a faltering wedged between them,
a sudden virgule she can't turn
into a hyphen's small wisdom.

Attempt at understanding:
futile as grabbing dust motes
in the curtain-filtered moonlight.

All she knows: how much
she wants to write herself home
into his hands.

from **Wresting the Grace of the World** (2005)

Narrative

I have a story to tell you.

It concerns birth and death, fire
and its implications, the yes-no dance
of life, which means choosing,
but not always the song.

It is the story of what is simple,
which is everything and nothing.

It is the story of absolute trust,
the path of no resistance.

Grass does not try to grow –
it grows.

The sun does not ask permission.

When you hear this story,
close your eyes.

Be who you are
when you're not looking.

Truth

You believe truth is truth,
immutable.

I believe some truths are
transient.

We've argued about this for years,
and still I maintain
that truth is
the ultimate shape-shifter.

How it appears depends
on where you stand,
and the light.

The Power of Glass

1

I place the glass apple
in the window of my room,
study it often while I work.

Admire its appleness,
its light-imbued solidity.

The Splendid Fruit
the artist calls it.

Enough weight
to shatter the pane,
remain intact.

2

My friend's mother escaped Hitler
by trading a vase for a ride across the border.

I imagine her forced departure,
her gratitude
for the value of leaded crystal,
the power of glass.

Gauntlet

I throw down my heart
like a gauntlet.

It lies at your feet,
a precocious invitation.

Will you pick it up?

And if you accept the challenge,
which challenge will it be,
to heal it or to shatter it?

This is the chance I take
when I engage you.

Above us, fate
circles like a hawk.

Safety, risk.

Out of this dichotomy
something slouches toward
understanding, waiting
to be born.

My Heart Hears You Dreaming

Years pass but I do find you;
your open self is still my fate,
such joy your mouth is speaking.

I sight-read each day as it comes,
listen carefully to learn by beat
the song of your softest breathing.

And within the silence that is love,
my heart hears you dreaming.

I am friend not foe, a soul
who treads gently through
the griefs you've been keeping.

A lover who loves your fluent hands,
evening sky in summer:
your blue eyes simply being.

And though I am not with you now,
my heart hears you weeping.

Through the landscape of my fear,
I braille my way toward trust,

weary but believing.

Yet despite the journey I have made,
the music weakens,
the distance is not receding.

And within the silence that is love,
my heart hears you leaving.

Daffodils

You bring me daffodils,
seven rows of seven
packed tightly
into a promising square of spring.

I place them on the kitchen wine rack
where they bloom
suddenly, tiny yellow flames
at first
like candle tips, then
insurgent bursts of yellow
multiplying eventually
into a miniature field of suns,
an eye playground.

But as the weeks pass
the fires die down;
there is nothing now
but a profusion of slumping stems
hanging heavily downward.

You have not seen
any of this, nor do you see
the care with which

I follow instructions, cut back
the wilted stalks, store
the bulbs in paper.

Will you be here in the fall
when I plant them,
these reminders of potential?

I gaze at the daffodils,
think of us.

I have always been a sucker
for symbolism.

Separate Venues

You and I are always
at a different place
at the same time.

Tonight, for instance,
you listen to your friend
sing jazz at a Toronto bar
while I, in my study,
listen to Bocelli
sing Italian romance.

You light a cigarette,
order another drink,
converse with strangers
(an art you have perfected).

I tuck my son into bed,
pour another glass of wine,
read *Artist on Fire*.

Fire has been my home motif lately—
a place rather than an element.

This has been my journey: to rise

out of deep water into air, grow wings,
fly over flames.

I have yet to be grounded.

And your journey,
what has it been?

Earth, water, air, fire:
which is your element?

Not air
since you and I
are always at a different place
at the same time.

Timing is Everything

The sun knows this, and the moon.

My heart also, as it clocks its way
forward.

And because timing is everything,
I wonder what's too soon, too late,
what chance missed altogether.

What if I had called you
at a different hour or on a different day,
in a different year perhaps?

Would you have loved me less or more,
or not at all?

Would I be sitting at this midnight desk,
mourning your arrivals, how they're played now
in a lower key, your leaving already audible
even as you enter?

Would I notice the wane of enthusiasm,
the barometric drop in passion?

If I had cherished your eyes
in a different season,
would my heart be different, or your hands?

My savage heart, your knowing hands.

A Common Story

There will come a point
when you can go no farther,
not in these shoes,
not on this road.

You know this, yet continue.

The weather has changed,
and so has the landscape.

What was once warm and avuncular
has now shifted toward cold;
the threat of rain is present always.

On both sides the forest grows denser;
it's hard to discern the individual trees.

You're afraid to be alone at nightfall,
walk faster though your feet hurt.

You long to turn back, but it's too late;
the road rolls up behind you like a carpet.

How you got here is a common story:
someone promised you safety,
and you believed him.

Night Shift at the Women's Shelter

I picture you in a pool of light,
oasis in the darkness; around you
rooms of sleeping women, you alone awake,
guardian of dreams, keeper of safety.

You pore over paperwork, the daily documents
of ruined lives rebuilding themselves,
your eyes tired, the tea on your desk cooling.

Every day you see it:
the bruised, betrayed face,
the intimacy of anger
distancing love.

You try to stay objective,
but it's hard sometimes, like now,
when you're tired, your tea is cold,
and it's so very late in the engulfing darkness.

from **The Burrs of Paradise**
(6 sections of 17)

3

This is one of those relationships
in which only the man is allowed anger.

The woman is allowed only patience
while he swings
his wide net of argument
over ten years,
triumphantly exhibits
his catch of examples,
all the things she's done wrong
slapped against her face
like wet fish.

As she sits drinking
cup after cup of coffee
in the sullen night,
she's well aware of what she's done,
what she hasn't.

Truth of self,
her only weapon.

It demands to be permitted.

It says: *Love despite all argument.*

It says: *Leave although you love.*

4

She tells him things about herself
but he doesn't believe them;
claims to know everything about her,
how she thinks, why she does what she does,
what she fears.

And what he doesn't claim to know,
he suspects.

His arrogance is astounding, sends
the part of her he originally loved
into hiding, like a fugitive.

He sees only what he wants to see,
like a scientist
doctoring his own research,
finding, at any cost,
what he seeks.

7

She's convinced
he should have been a lawyer.
He interrupts, deliberately misinterprets,
shapes the testimony to fit the crime.

The facts bray at his command;
arguing with him is useless.

He's perfected
the cross-examination art,
the basic tenet: never ask why
unless you already know the answer.

8

At dinner, lobster shell
slicing her thumb, butter
trickling hot down her chin,
she asks him if he's dangerous.

There are stories
the man next door
who shoots his wife, kids, dog
unexpectedly, without reason.

He was a quiet guy,
the neighbours say,
kept mostly to himself,

washed his car on Sundays.

The lobster's claw is obvious.

More frightening:
the boiled and bitter eye,
what's missing from it.

13

She has been sleepwalking for years
in the vicinity of the precipice,
has stumbled perilously close,
the danger unrecognized.

Except in dreams
where his shadow stifles her
like a coffin lid, and her own
hovers uncertainly
in a background she can't see.

Yet she can't resist,
can't help but wonder
what would happen if she took the chance,
leapt into the fear,
awakened.

Would she see her shadow?

His?

17

She comes upon him in the small light, moon
struggling through the window,
his self well hidden in sleep.

She unfolds against his back with certainty.

She is growing on despite him.

Five Facts About Photography

No past or future,
just one
continuously present moment
framed by fate
and the photographer's eye,
serendipitous collusion.

Beneath every photograph,
an invisible caption:
Who holds the camera?

The camera, like the gun,
has no motive: it's aimed,
it shoots.

What matters:
light and motion,
how much, how little.

Context is outside
the frame, always,
and there's no such thing
as a whole picture.

Hindsight

She heads out of one city toward another.

It could be any city, the city
doesn't matter.

The trunk of her small car
brims with cameras, tripods, flashes, film.

She's listening to something rousing, symphonic
(*A Little Night Music* or Beethoven's *Ninth* perhaps)
her gaze on the road steady, her hands on the wheel
relaxed.

Above her, airborne, you too are travelling
from one city to another.

It could be any city, the city
doesn't matter.

Your thoughts are starkly clear,
as they always are at high altitudes.

In your lap: books, pens, sheets of paper
filled with words about men, a man,
relationship.

The voice in your head says
Fix it or finish it.

You listen.

What neither you nor she
can possibly suspect:
that you will be in the same city,
and it will matter.

Geography Lesson

Teach me the landscape that you love,
the west that is more than a direction.

Teach me the shape of deer prints,
mystery of medicine wheels,
the stirrings of the vibrant earth
as it sings in stone and tree bark.

Teach me the poetry between the rail lines.

Teach me the true teal of the Bow River,
the nuances of light on wheat fields.

Teach me the vertigo of pure prairie darkness,
its surprise of stars.

Studio Scene

Picture this as a photo shoot.

The backdrop is lowered,
winter seen
through large glass doors,
snow-mounds on the deck,
stark white on dark blue chairs.

A woman in jeans and sweater
(also blue)
lies stretched on the green couch,
relaxed hunter.

A cat sleeps at her feet.

You are the photographer;
you notice things.

The woman's hands,
their long, slender fingers;
her blue eyes
backlit by the January light;
the way her hair frames
her face; the shape
of her mouth, tilt of her chin,
the exact position of her body.

The truth of her
in that moment.

Photograph: The World

You send me a picture, taken
just hours before I dialed your number
on that pivotal November evening.

From a space station, panoramic view,
the Earth at night, caught
with all its lights on.

Our two cities
miniscule bright dots
within the glow fields, and us
within them, somewhere.

Always of interest: what is made
invisible by distance, what is
revealed.

It was as if, in those hours before
I phoned you, the universe
cleared, made space.

And now, months later,
you send me
this picture of the world,
how it was, before
we re-connected.

The Persistence of Vision With Regard to Moving Objects

The human eye holds images
a fraction of a second longer
than they are in sight.

Each such instant: an interstice
like the space between the shoe
and the foot in it, the act
and its consequence.

After each frame, unnoticed,
the next moves in, smooth and discreet.

The eye thinks it's looking
at one image only: illusion of motion.

In this way my eyes hold you,
frame to frame to frame.

Create their own illusion,
fill you in.

Lighting Ratio

You set me up, today's subject,
in the same room with yesterday's model.

You've decided you want us both
in the picture.

Light enters, either natural
or not.

Consider the difference
between who receives the most light,
the least.

Attend to intensity.

This will affect contrast, softness,
the range of greys.

It will also affect clarity.

How much light
you allow, and what kind,
will determine the outcome
of the picture.

I trust
that you know this.

Monet at Giverny

Water lilies, weeping willows, wisteria.

Shadows vibrating
on the famous footbridge.

His eyes obsessed for a lifetime
with the transformative power of light.

His dream: to master colour
as it masters him, to paint
exactly what he sees.

But sight is fickle, alters
and distorts, weakens
and eventually fails.

What's left: the vision
that never depended on the eyes.

A Portrait of Home

The choosing is what frames it: joy,
a sky address, habitat
of birds, clouds, all celestial bodies,
the harlequin beauty of light and darkness,
soul space, open.

And in this, our days together
a graceful tessellation of sleep and waking,
peace, and
a startling tenderness.

You are my place of wonder,
my continually arriving destination.

Home, the choice I make
each moment.

from **In the Key of Red** (2010)

Life Song

Life, I sing you in the key of red,
no matter what the colour of the day.
In the key of red, I sing you,
both major and minor,
every variation
possible on the scale.
And when my song is over,
night darkening the day,
even the black
will be chorded with crimson,
the red won't fade away.

The Way I See You

1.

Sometimes you are a woman of the cave,
a bliss artist in torn jeans, T-shirt
the colour of earth,
caressing heads into existence
with practiced fingers.

You sculpt wonder, shape discovery,
give form
to what you don't yet understand.

Stones and steel, glass and pearls
adorn your creations, each face
a surprise,
an arrival of becoming.

2.

And what is art
if not a form of love?

I think of how you once
stroked the thigh of Rodin's Adam.
Now your hands move

with the same fierce tenderness
on clay, on me.

3.

Sometimes your arrival surprises me.

You cross the room
in the late afternoon light,
a bliss lover with amber hair
and a stunning nakedness.

Your hands promise wonder and discovery,
give form
to what I don't yet understand.

But it's what I cannot see
that I love most: your soul
templed in your body, the altar
at which I worship,
which alters me.

Seurat's Sunday, 1884

An island on the Seine,
summer afternoon, a park
adorned with the well-heeled,
their elegant clothes, their pets
and parasols.

None of this matters.

What matters
is the eye of the artist
which penetrates
the world's shimmering
surfaces where points of colour
vibrate faster than the wings
of hummingbirds, compose themselves
into clusters of movement so rapid
they create
stillness.

The paradox
of energy shaped into matter:
everything moves,
nothing moves.

Drawing Hands

I return, return again
to the hands drawing themselves,
Escher's circle of creation
I first discovered at twenty,
a small copy still tacked to my bulletin board.

It is the image that my son, not much older now
than I was then, has picked to be his screen saver.

I tell him how his father and I used to
study Escher, the complex perspectives
possible in art, in finite lines
the infinite captured, motion and stillness
simultaneous, stairways to heaven and hell
both in the same direction.

An odd comfort, to speak of paradox,
its challenge and its blessing.

An odd comfort too, the immortal hands
emerging continuously from the blank page,
caught forever in the moment of being born.

Inventing the Future

What doesn't break us binds us.

March again. The earth softens
as spring lays its green foundations.
Never the same spring twice,
never the same March.

I have been lashed by grace. This is
a new way of being in the world.

A blessing, this,
for that which no longer changes
is perfect and dead.

I lean against the balcony railing. My eyes
embrace the Don Valley settling into dusk.

You slide open the door, stand beside me.
The last vestiges of sun
alight on your hair before the sudden darkness.

A choice: what it is we hoard,
what it is we wager. We reveal ourselves
when it hurts more to remain hidden.

Eventually the stars appear, and the moon.
I bow to their light, and to the light in you.

Love strikes me open. What pours out is love.

Reclamation

Darling.

As we stand before the window
in our private morning,
I reclaim the word
from all your past lovers.

The sky stammers,
breaks into light, reveals
a palette of birds at the feeders:
blue jays, cardinals, a shock
of yellow finches.

Our small world
sings its green vernacular,
its language of growth.

Darling, I say,
with the absolute trust
of the bird for its wing.

A word-seed,
love.

You

You
are not the whole world to me.

The world I love
is manifold, and you
are its particulars:
the duet of day and night
singing forth light
and darkness, the slant of sun
on the vase of Parrot roses, the birds
winging warm
against winter's cold shoulder,
the yellow nest-bed
into which the cat
fits her affectionate curling.

The world I love is many things,
all of which now are partly
you.

Absence

You were not here
and nothing could negate
your absence.

Your absence was everywhere
and everywhere I looked
all I could see was not you.

Labour Day

Another weekend, you're not here,
and every moment turns to past
presently.

Already the air is colder, night
falls faster, the flowers
struggle.

It's work to stay warm, the hours
drone on, the seconds
click like camera shutters.

There's no denying history:
we can't unlearn what we've learned,
undo what we've done.

I think yet again of your absences;
I think of my absurd, persistent caring.

Remind myself that loving you
was no mistake
and that it's not the death we fear
but the dying.

The Song

When the song comes on
you're in a store on Yonge Street
checking the weight of backpacks,
the durability of boot soles.

And because music is memory,
you can't help but think of me.

It annoys you, this blip
on your emotional Richter scale.
Yet you continue to listen, linger
among the running shoes
and sturdy denim shirts.

For a moment
you wish I was there,
standing next to you
among the survival gear,
helping you
survive.

Outcome Unpredictable

I walk the road to Hanlan's Point,
the late afternoon sky moody:
sun to cloud, grey to bright,
outcome unpredictable.

Across the harbour, the CN Tower:
unflinching urban totem.

So near yet so far, the city.

I keep walking, walking,
the day drops toward evening,
the tower continues to tower.
Somewhere east of it, you move
through your day, becoming
someone you don't yet recognize.

Grief has had its way with you,
and anger. And whatever there was of love.

It was love that made a nest of us
and whispered promises of home,
love that broke us in, beckoned us

toward healing.

Love was what held you,
watched you sleep,
began anew each morning.

It was through love that love was gained.
It was through love that fear entered us.

And as I walk the road to Hanlan's Point,
I think of you, so near yet so far,
and whatever there was of love.

Orchard

Around us, a calamity
of red, the urgent apples
falling, the late October leaves
falling, brittle branches
breaking in the wind,
falling.

So much now
grounded.

We continue on our awkward stilts,
grow taller in time.

We accrue years, construct height,
believe our measurements.

It is only when we reach
our possible altitude
that we turn our attention
earthward
to all the spectacles
of smallness.

We realize time
is not outside us.

Even so, the wind
will bring us
down.

Moving Day

1.

It is the last time I will see you:
your choice.

You arrive with your entourage,
come through the door sideways,
try to keep your back to me, avoid eye contact.

You head to the basement, your stored boxes.

It doesn't take long for the men to load the truck.
It's a hot day. They're sweating.

I watch you as you stand in my driveway.

Your profile is stony
and you've aged these past weeks,
grown suddenly old. Or maybe not.
Maybe you've just stopped pretending.

I go outside, face you.
Ask if you're all right,
ask if you'd like water.
Although it appears to be,
this is not forgiveness.

2.

In the evening
my friend and I help her daughter
move to a new apartment.

When we arrive, her daughter
is unpacking boxes.
The fan hardly pushes the air.
The humidity hangs heavy,
then heavier.

Her daughter offers us a drink of water.

On the couch: a boy of thirteen
who looks no more than seven.
He loses control, twitches
and spasms in the heat.

My friend takes the boy in her arms,
cradles him, speaks to him softly.
He does not take his eyes from hers.
His gaze holds.

It doesn't matter what this looks like,
and it's not pity.

How It Happens

A space must be maintained or desire ends.
—Anne Carson

1.

My closed eyes, your touch.
In your hand: such gentleness.

Against my back
the late May grass still cool, spring poised
to cartwheel into summer.

Beside us, ducks in tandem,
a silent small flotilla, the restiveness
of the quiet morning river
deep and invisible.

We rejoice in the giddy flowers, flashes
of cardinal, the poplar leaves
catching the light like green jewels.

Everywhere growth beckons.

2.

Sometimes we walk toward,
sometimes we walk away.

We have been walking away from others
for a long time.

We have been walking toward each other
for a long time.

3.

Gradually, layer by layer,
I let you in.

I am a series of nesting dolls which
you open, each smaller than the next
until, at last, you arrive
at the core of me.

Sweet shedding of skins,
a way of re-beginning.

4.

To take the first step: to take,
for it is never given.

The first step: away and toward
at the same time.

5.

Time hastens on, unstoppable.

It is now a different season.

Our closeness has grown heavy,
we have seen too much
of each other.

You claim space has eluded you.

The irony of growth:
it happens in all directions.

This, too, a process:
the way I replace myself
layer by
layer, carefully,
the child
first, until finally
I am once again
safely hidden.

You face away from me,
gauging distance.

You think you know
where you are going.

I regret your turned back, stand
firm in my stillness, do not walk
from or toward
anyone.

Answer

It lasted all summer,
the long search for resolution.
You yearned for compass, telescope,
instruments of gauging.

You wanted to magnify
and get direction.

You longed for someone
to tell you what to do.
You wanted certainty.
You wanted the right answer.

You had no way of knowing
that whatever answer came
would be impossible.

The End of Something

I seem to have come to the end of something, but don't know what…
—Charles Wright

The conundrum of ecstasy: that it begets
longing, and longing is pain, longing is lack of.
For once you've known ecstasy you are not satisfied,
you want to know it again. You yearn and yearn.

Yesterday I dreamt of a winter room, my father
in a hospital bed, everything incredibly bright and stark.
The walls, the sheets, the blinds. My father's skin, his hair.
So much white it hurt.

And now I think of you
at your desk as the snow falls on this January night,
polishing words late into the dawn hours,
page after page of paper at your feet.
Such power in composition: the treachery of a comma,
the imperative of a period. Such grace, if you allow it.
But always, at the beginning, so much terrifying white.

Sometimes the words are dangerous.
They fly at you like sharp steel shards,
fragments of shrapnel, brutal as truth,
fatal as lies. But sometimes the words
are green, an alchemy of growth

vital as birdsong, as old and as necessary.

You once said: *When you lose your faith in love,*
you lose your faith in words. Love had failed you,
or you had failed love. You weren't sure which at the time.

You had known ecstasy, that fickle mysticism of the heart.
It changed you, but you continued to dig for the words,
haul them out of the dark, out of the deep mire, assemble them
like ancient bones with which to re-construct your humanity.
And so you mended yourself, fed your heart to life.

Poetry is the language of belief in language.
What we look at deeply, enters us. This you said also.

What you will say when I tell you my dream:
Your father is dying and everything matters
and nothing matters and now you think
you've seen the worst but you haven't
and will it end, yes, it will,
everything does, nothing does,
and perhaps when your father's entire house is empty
you will find that all along
you had more room there than you knew.

* * *

My father believes in numbers, trusts their provable certainty.
He likes what can be demonstrated. Words are unsolvable.
Too many variables, too many meanings.
He prefers fact to nuance.
My father believes in descriptive geometry,
three-dimensional objects rendered in two dimensions.
He believes in detailed designs, feats of engineering.
When it comes to metaphor, he is an atheist.

My father has become acutely aware of time passing.
He orders the calendar removed from the wall.
He exiles clocks and watches, abolishes the daily newspapers.
He forbids reminders.

Within my father: something that pulls his eyes shut
just as he is about to see.

Within my father: a sad melody
he doesn't want to hear.

What I want to tell him:
The world continues to speak
even when you don't listen.
The world continues to sing
even after listening is no longer an option.

My father does not repent.
In the act of falling, the rising is promised.
These are not lies, but truths before their time.

* * *

In a World War II prison camp
Messiaen composes the *Quartet for the End of Time*.
It is performed on a savagely cold night in January 1941,
the air so cold breath barely moves through the clarinet,
the air so cold it numbs the fingers of the violinist, freezes
the strings of the cello, ices the piano keys. But on this cold night
spring dawns, birdsong lifts the heavy human heart.
History enters the room, asks to be forgiven.
Hundreds of prisoners permit themselves again
to feel what it is to feel. Such music
makes the promise of salvation possible.

Even the guards are moved, especially one,
who gives Messiaen the pencils and paper and space
for composition. The one who years later Messiaen
will refuse to see when he knocks at the composer's door.
The one who will die shortly after when a car runs him over.

The wars have not diminished.
And what do we know of them
in our tiny worlds, our footholds in the mud?
But among the roots, evidence of wings.

My father: a boy of ten in 1941,
imagining motors, parts fitting together,
useful and visible. He despised the Nazis
but has always admired German precision.
Throughout his life, his favourite past-time:
constructing radio-controlled model airplanes.
One of my childhood memories: the whining buzz

of the miniature machine, an extension of my father's will
as he regulates the magic of flight.

<center>* * *</center>

What my father won't answer is everything that questions me
(silence too a form of exile). I argue against his dying
as only a child with unfinished business can.

My father lies in his hospital bed.
We can't pick up where we left off.
My love offends him.

I tell you about my father, about the music
that is a form of God redeeming God, I tell you all this
because for you, my empathetic friend,
there is no gratuitous sorrow, no cliché of compassion.
You say: *Finally it is the door that matters,*
not whether it is open or closed but whether you walk through it.
And you will, when love commands you.

<center>* * *</center>

Decades after it was written,
I listen to the *Quartet for the End of Time.*
The music is still with us. Time is still with us.
Out of the past a clarinet calls, trills.
The music transgresses and transcends.
Eventually it moves beyond joy and sorrow
into that fiercely painful beauty which encompasses both.
I picture you, my friend, on this January night,
old-fashioned writer that you are, one who still takes seriously

the seriousness of words. I think of the black ink that flows like oil
from your pen, spreads slowly across the pristine page,
incendiary. How your words, when they are spoken,
are sometimes hot grace that scalds the lips,
sometimes sweet as birdsongs, small celebrations that cool the tongue.
And even when we think art fails us, it doesn't fail us.

I think of my father, the father I have lived a lifetime without.
Guilt stands in the vast distance between us,
stalwart and immobile as a soldier.
A two-sided Janus, it faces us both.
My father turns his back. I stare and stare.
Guilt stares back, its eyes lidless. No contest.

So much to say before it's over.
Elocution of fire. *Bring it on,* I say.
Bring it on in the cold morning.
Don your fortitude, Father.
In your final moments, I could be a birth.

Beginning

You begin somewhere, perhaps
it is on a road or a bridge
or by the river that runs beneath it.

Perhaps it is at the foot
of a 500-year-old maple
whose October branches vault above you,
autumn cathedral.

Wherever you are, it is
a moment and a place:
unique conjunction.

Your life has brought you here,
will take you away.

So consider your options:
will you pull a leaf from the tree
or simply wait, do nothing.

One thing you've learned:
everything falls.

New Poems

The Love Song of Dora Maar

1

It all begins with the mouth,
but I don't know this; for a time
remain convinced it begins with the eyes
which watch me play my little blood game,
the knife thrown down between my fingers
as they lie spread on the wooden table.

Your friends say that art should be convulsive,
and so it is, the vulgar rose
that masquerades as your heart.

Your mouth will be a later cruelty.

2

The first time you come to me
I take surreptitious pictures of you.

They remain my secret, these negatives
which I never print.

In my drawer you will remain
black and white reversed, forever radiant.

Your image: caught lightning.

3

You note my hands, their slenderness,
long tapering fingers, carefully manicured nails
in various colours – blue, green, red, black –
whatever my mood that day.

You come to see me as a clawed and clawing creature:
Sphinx, phoenix, always something hungry.

You are afraid you might fall under
my unpredictable nails, that I will tattoo you
with invisible private hieroglyphs
while you press versions of my various selves into paint,
hold them there forever, my artist jailor.

4

Mougins, 1937.
The world still light, the darkness on the horizon
not yet arrived.

We play at poetry, pass our words
back and forth on hotel stationery, each
determined to outdo the other.

It is forever hot noon, the sun at its zenith,
the time when our shadows are smallest.

I cage you under the bamboo awning,
create you in stripes, light and dark alternating.

At night like spies
we watch each other sleep,
own each other best then.

5

The heaviness of all the unsayable things.

How do I stop considering you?
How does one feign indifference to the sun?

6

1941.
Although the world turns on itself, feeds
on its own entrails, its numerous and lavish horrors,
we abide.

My fingers boast dark talons sharp with rage.

You paint me with a black cat
on my right shoulder, your pagan goddess
on a soon-to be-toppled throne.

Private Lilith, sorceress, terrifying muse.

7

Exacerbated summer,
ferociously lit.

You use me up.
I am the fuel, consumed.
Those who look too closely
will burn their eyes.

In the perfect sun:
my heart a seed, concentrated and silent;
my skin open to the light that bores in
through every pore.

Each day I am a darker version of myself,
a latent explosion, a small star gathering inward.

8

You paint me as a bird.
You paint me ravaged by the Minotaur.
You paint me as angles.
You paint me in pieces.
You paint me in tears.

I am a prism
through which you break
into all your magnificent colours.

9

Later I will say, *After Picasso, God.*
For now: one and the same.

But beware, my gargantuan little hero:
I channel the wounded wolf
and there is appetite in all my actions.

Everything eats, one way or another.

Pier's End

I am headed to the end of the pier.
Couples stroll by hand in hand.
They address their dogs,
smile—or not.

There are others, like me,
who walk alone.
Our solitudes greet,
pass on.

Two lakers hold the horizon line
waiting in a stillness
that cannot be measured.
The stillness waits also.

Today the city is not
visible across the lake.
Some days it appears
distinct and familiar,
a small mirage in the far distance,
lit at night with the alluring promise
of whatever it is
that cities promise.

I keep on, reach eventually
the pier's end, look back

at where I've been.
Think of Rilke crying out to the angels
in the hope that they would hear him.

A cry of the unsafe heart
gnawed by its own wild teeth.

Fear

The great wave of Hokusai
rears out of the lake,
a charge of white horses.

We go under
never to return.

Paradise

It could not have happened
any other way.
Paradise provoked you.

The lake was too blue,
the sun too bright, and when it set
the sky was always a postcard.

Comfort sat on your shoulders
like a mountain.

Weeks passed, then months.
Wine flowed, music was repeated.

You knew it would be ungrateful
to be anything but happy
and so you prayed for gratefulness.

But there was an absence you tongued
as you would the space
left by a missing tooth.

Nothing could assuage
your awareness of it.

You smiled through the days

with a radiant diligence,
eager to please the powers
that had blessed you.

You admired and praised in earnest
while your wily heart
practiced its subversive magic,
swallowed fire,
harnessed lightning,
prepared to explode you.

Wish

I wish for both of us
all the love we thought
we had.

I wish for both of us
forgiveness for all
that we mistook for love
but wasn't.

Because of love, I came to you.
Because of love, I leave.

Let me.

There Comes That Day

There comes that day
when we know our knowledge
is ignorant, facts ·
of the decoded world, not deep truth,
mere information.

I say then to my heart:
listen. Listen
to the impossible silence
at the moment of departure.

And if you listen closely,
you might hear the voices
of survivors surviving
and make of them a ruinous music,
song for the kneeling.

Oh my stupid heart,
how you destruct me.

Understanding

I do not understand
the iron thread that binds us.

I do not understand
why the spider's web on the side-door mirror
continues on unbroken
even as the car speeds away.

I do not understand
the vagaries of love
nor their implications.

All I know:
we are wind and wing,
a perfect pairing.

Once Again, the Moon

Once again,
the moon outside my window.

A full moon
in the pre-dawn November darkness.

What can be said of the moon
really?

The moon has been, always,
but I am new.

I watch as the light slowly comes,
gradually erases the moon.

The bittersweet crux of humanness:
I know
that unlike myself
the moon will always return.

Apartment Memory

I arrive early.
The cat purrs her greeting,
waits for me
to remove my coat, enter
the space completely.

You have left the lights
and music on in welcome.

I stretch out on the couch.
The cat settles on my chest,
our affection mutual.

Within minutes, the familiar click
of your key in the door,
and there you are, in from the cold,
eyes warm as summer.

You unzip your jacket,
lean over to kiss me
as your hair falls around us,
brushing my face like a blessing.

The cat does not move.

If I asked you now,
what could you promise me?

Morning Variations

1

In my dream
I dreamt that I was dreaming.

And in this dream-within-a-dream
I held you close, could feel
the warm weight of you
pressed against me.

I held you for a long time.

When I opened my eyes,
I saw what I was moving toward.

When I closed them,
I saw what I was leaving.

In the small movement of my eyelids
I saw the difference.

2

I awoke, having dreamt of you.

The morning was cold
and so was I.

The mug of coffee warmed my hands
as I remembered the heat of you.

Across the lake the city shimmered,
miniature dark monument
to what I had relinquished.

I wanted to return
but didn't know how.

And then I realized
there was nothing I could do
except everything.

In Our Next Life

I hold the Lion's Paw whenever I dance.
<div align="right">—Hafiz</div>

In our next life, we will be lions.

We will roar and purr, our purring
a deep rumble of content
tendering our solid bones.

We will be strong.

We will love
as only the wild can love:
without fear of abandonment.

Untamed, innocent of consequence,
we will live out our timeless days.

Although I will have no words for it,
I will notice how the sun goldens your mane
and turns your eyes
into small versions of itself.

I will love you
and not know I am loving you.

We will eye the world
through our singular togetherness,
unaware of our majestic coupledom.

I say this now
on behalf of the future, when
as wordless, blissful lions
we will surely meet
and, without knowing it,
recognize each other.

We Speak of Many Things

1

We speak of many things,
lately of how life folds
over the deceased as water folds over
whatever enters it.

Those we love vanish
as if they had never existed.

We mourn them with memory,
repeated recollection.

We mourn them with laughter,
mourn them with tears.

With prayer after prayer we mourn them
yet gone they remain.

2

When you heard your friend had died,
you were alone in your car
on your way to work in the early morning.

The call came on your cell phone,
sudden as lightning and less expected.

You pulled over, irrevocably shaken.

Later you told me you couldn't understand
how the traffic could simply keep moving,
how nothing stopped, not even for a moment.

How death had made
not the slightest ripple in the world.

The Father Speaks

The ocean between us
for your first six years, my daughter.

What light, what dark,
how many turnings of the earth,
how many cycles of the moon
between us, between our
parting and our meeting.

What pain, what love,
how much of us made
between birth and death,
how much of us reduced
by anger, expanded (finally)
by understanding.

Remember: I held your hand
when you were too young
to know it.

Song of the Son

The city in summer, morning hum of traffic,
everywhere an eventful beauty
which slows and quickens, refuses to stay still.

As I walk, I plan my future.
I am young and tall,
a thin wire of energy.

Like the Tarot fool,
I am a beginning, an adventure incarnate,
a spirit strong with certainty.

Behind me, my dead father.
Beside me, my mother
moving aside, letting me go.

Ahead, the mysteries
of my own choosing.

I am precisely who I'm supposed to be.

This is grace:
the way the angel
blesses the work of the clown.

What You Wished For

You wished for journey
and the road came true.

It was not what you expected,
more a trail than a road, rough
and dark with trees.

It took you deeper,
deeper still.

Soon you were lost.

What saved you: the words
you dropped like crumbs
along the way.

They helped you find your way back.
This time.

Two Perspectives

1

My grandmother used to say:
if a violin string breaks, no matter
how meticulously it is mended,
it won't give its true pure sound.

It will never recover
from being broken.

I think of relationships,
their breaking and their mending.

I think of us.

2

You tell me of your time at St. Paul's,
of the man tuning a piano
one note at a time, the painstaking constant cycle
of one attempt, then another,
each note ringing, resounding,
resonating into the great dome.

You tell me how clearly you could hear it,

the slow process, and eventually the correct pitch,
the success of the patient tuner.

You tell me how you stood there,
thrilling to the certainty
that everything comes back to centre
if you allow it.

Awareness, desire,
with patient tuning, the two of us back together
at the core.

Lakeside Carousel

This, the last day of the season,
finds me straddling the prize of the carousel,
a one-of-a-kind lion.

Both of us, heads turned fully sideways,
stare out defiantly at the crowd.

The lion, hewn of what is now
hundred-year-old wood, was carved
by the hand of a master—compelling
as only the unique can be.

When the music starts, the lion
remains anchored, does not rise and fall
but stays still in its circular journey,
orbits the music box
as the earth does the sun.

Behind me my younger sisters gallop
on their up-and-down horses.

They can never catch up.

Meanwhile the music carries on,
one song after another.

And so it continues and continues,
my ride on the back of a ferocious art.

Art

Driving to work in the rain,
the traffic lights reflected
red, yellow, green in the wet autumn pavement.

Sudden memory from years ago:
my friend splurging her first adult earnings
on a Philip Surrey painting she'd fallen in love with
and, in the way lovers crave possession, had to own.

I understood perfectly
her romance with the artist's slick urban night,
to this day pair my own rainy cityscape
with Surrey's neon vision.

And so it is that art creates us.

Acknowledgements

"Apple Meditations" is for Dianne, Darlene, Ricki and Kim.
Part 2 of "Moving Day" is for Barbara Fennessy.
"Harvest Moon" and "We Speak of Many Things" are for Darlene Hareguy.
"Sun on Water" is for Patricia Keeney.
"First Friends" is for Susan (McIntosh) Larsh.
"Drawing Hands" and "Song of the Son" are for Brendan McCarney.
"The Way I See You" and "Two Perspectives" are for Constance Rennett.

"The End of Something" is dedicated to Anne Michaels.

I would like to thank the publishers who brought out the original books from which the poems in this volume are taken: Aya Press, Thistedown Press, Black Moss Press, and Inanna Publications. In particular, I am deeply grateful to the original founders of Thistledown Press in Saskatoon – Paddy O'Rourke, Al Forrie and Glen Sorestad – for believing in my work when I was still just starting to discover my own voice and for putting that faith into action by publishing three volumes of my poetry.

Thank you to Patricia Keeney for her care and attention in choosing the poems for the Selected sections. Also, thanks to J. S. Porter for his insightful introductory essay; to my publisher Luciana Ricciutelli for being the wonderful publisher that she is; and, finally, to Jeanne Hamilton for much kindness in many ways.

I would also like to pay tribute to the memory of my grandmother, Elizabeth Kalán Tihanyi (1905-1995). Without her loving support and

encouragement of her poetry-obsessed granddaughter, this book might never have come to exist.

Any book that spans over thirty years of work also spans over thirty years of experiencing the world, and so I thank all those who in ways both large and small have enriched my journey thus far. The poems could not exist without the life.

Photo: Barbara Bickel

Eva Tihanyi was born in Budapest, Hungary, in 1956, and came to Canada when she was six. She has taught at Niagara College since 1989 and lives in Toronto and Port Dalhousie (St. Catharines, Ontario). *Flying Underwater: Poems New and Selected* is her seventh book of poetry; she has also published a short story collection, *Truth and Other Fictions* (Inanna, 2009). Tihanyi, who has been writing poetry since the age of fourteen, long ago took to heart Adrienne Rich's words, "I will submit to whatever poetry is," and continues to view the world through that lens. Visit her website <www.evatihanyi.com>.